This Book Belongs To:

ERNI CABAT'S MAGICAL WORLD OF THE

CAROUSEL

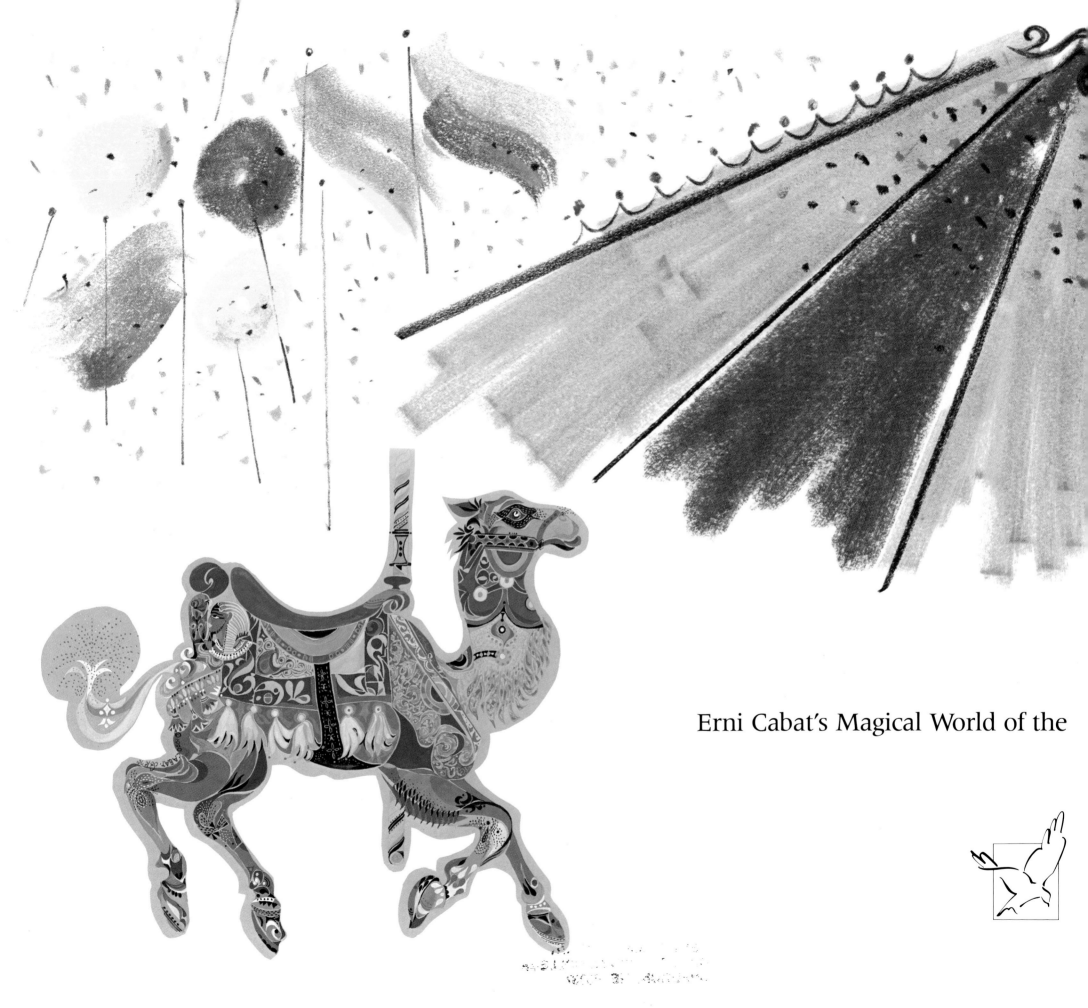

Erni Cabat's Magical World of the

CAROUSEL

Paintings by Erni Cabat
Verse by Constance Andrea Keremes
Foreword by Tobin Fraley

Harbinger House
Tucson • New York

Harbinger House, Inc.
Tucson, Arizona

Illustrations copyright © 1990 by Erni Cabat
Text copyright © 1990 by Constance Andrea Keremes
Foreword copyright © 1990 by Tobin Fraley
All rights reserved, including the right to reproduce
this book or any part thereof in any form.

Printed in Singapore through Palace Press.

Designed by Erni Cabat and Nancy J. Parker

Library of Congress Cataloging-in-Publication Data

Cabat, Erni.
 Erni Cabat's magical world of the carousel.
 1. Cabat, Erni. 2. Merry-go-round in art.
I. Keremes, Constance Andrea. II. Title.
ND237.C14A4 1990 759.13 89-26890
ISBN 0-943173-60-4

Foreword

The carousel business is not something you can just get into like accounting, marketing, or computer programming. There are no college courses, no professors, no textbooks. High school guidance counselors don't offer it as a career option. And you certainly never see any classified ads for carousel restorers in your local newspaper.

Nevertheless, I found myself in the carousel business eighteen years ago. And when I piece together the memories of my childhood experiences, it's no wonder. In reality, I spent most of my life preparing for this career without really knowing it.

Growing up in Seattle in the 1950s, I was the only kid on my street with a grandfather who owned an amusement park. Like any child with an amusement park in the family, I took full advantage of it—going on the rides for free, eating all the hot dogs and popcorn I wanted, doing the things most kids only dream about. I even enjoyed the park when it was closed. In fact, I probably enjoyed it even more then. I would wander around the empty rides, making everything come alive in my mind—listening to the band-organ music of the carousel, seeing the horses chase one another in endless circles but never quite catching up, watching the roller coaster chug slowly to the top of a huge summit and plunge down at full speed, hearing the kids scream and shout.

In 1961, the park closed. My family moved to Berkeley, California, but we brought the carousel with us. Our new home was a bit unusual, even for California. We kept at least five or six carousel animals around the house at any one time, lounging in the living room, standing guard in the bedroom, looking over our shoulders when we ate dinner. My parents also owned an art gallery, where they displayed several animals that outgrew the house. Little by little, they began doing work on some of the more ornate creatures, stripping off the old paint, repairing any damage and putting on a shiny new coat. In the gallery, they sold some of the figures, bought others, and developed quite a reputation in the mid-1960s for dealing in carousel "art." By 1969, it became their full-time occupation.

Over the years, both my parents and I grew curious about the origins and history of these wooden creatures. Our research turned up some surprising information.

In the court of the French King Charles VIII, each year there was an event of pomp and pageantry, called *carrousel*. *Le Grande Carrousel*, the most lavish of all, was planned by Louis XIV in 1662 and featured several games, including the medieval sport of ring piercing once played by the ancient Moors. This called for great concentration, agility, and horsemanship, for the object of the contest was to pierce a small ring with a sword, while riding at full speed.

To train for the game, participants rode legless wooden "horses" on beams that circled a central pole. Powered by a real horse or a servant, the rotating riders tried to lance a ring hanging just outside the circle in this primitive predecessor of the modern carousel and its game of "catching the brass ring."

By the nineteenth century, the practice machine had become sophisticated, with a whole variety of animals going around in circles, but the carousel's weight and size were still limited by its rotation power, which, up until 1865, was supplied by a horse, mule, or man. It wasn't until then that an Englishman named Frederick Savage put steam power to work, and the carousel achieved its present-day stature.

In 1860, a twenty-year-old man named Gustav Dentzel arrived in Philadelphia, where he settled and opened a cabinet shop. His father Michael, who carved horses and constructed carousels in Germany, encouraged Gustav to build his own carousels in America. The young Dentzel took his father's advice and built his first machine seven years after emigrating to the U.S. His new business venture was so successful that, in 1867, Dentzel renamed his cabinet shop "G.A. Dentzel, Steam and Horsepower Caroussell Builder."

In 1880, a competitor came upon the scene, a man by the name of Charles Looff. Looff leaned toward a more fanciful design in both his carousels and the buildings that housed them. He added glass jewels and beveled mirrors as trappings, created ani-mated leg positions for his horses, and carved wild manes, often using gold leaf. His use of electric lights and colored glass in the windows of the carousel building further enhanced the highly decorative nature of his animals. Looff's flamboyant design style became his trademark, heralding the beginning of the "Coney Island Style" of carving.

In 1884, Charles Dare planted the seeds for the third distinctive style of carving—the "Country Fair Style." These carousel horses were carved primarily for traveling carnivals and country fairs. Their figures were lighter, smaller, and built for easy handling, packing, and transportation. On-the-road carousels also created the need for simpler trappings, sturdy, parallel-leg construction, and either very small or replaceable ears.

The carousel industry flourished until the onset of the Depression in 1929. Several companies stayed in business by making horses out of cast aluminum, but by the 1950s, the art of carving carousel figures had passed. Only through the love and interest of people like my parents and myself, and others who cherished their memories of these animals, did they survive.

Over the last eighteen years, I have worked with many carousel animals, and it has been a uniquely fulfilling and satisfying experience for me. It feels wonderful to restore these worn, weather-beaten, mistreated figures to their original beauty, majesty, and artistry. And the results are often so dramatic that the animals seem really to have come back to life.

But though I could repair, refinish, and restore these magnificent carousel figures, try as I might, I could never recapture the joy they brought to countless children over the years.

Erni Cabat has done just that.

He has gathered together the very best menagerie animals and carousel horses and transformed them with the magic of his paintbrush. Erni's animals are exuberantly alive—they bound, gallop, glide, waddle, strut, and prance across the pages that follow.

Come see for yourself and enjoy!

TOBIN FRALEY

Adapted from *Carousels: The Magic, The Myth & The Memories*, copyright © by Tobin Fraley.

agle is my brother,
　　We are creatures of the sky,
Each time he soars above me
　　I feel I too can fly.

Eagle beats his wings in flight,
　　My hooves begin to pound,
But though I strain to touch the clouds,
　　I cannot leave the ground.

Yet I am not discouraged
　　In the shadow of this king,
For as I run, my spirit lifts
　　As though it might take wing.

And when brother Eagle wakes
　　To greet the rising sun,
His joyous heart beats in my breast
　　And we become as one.

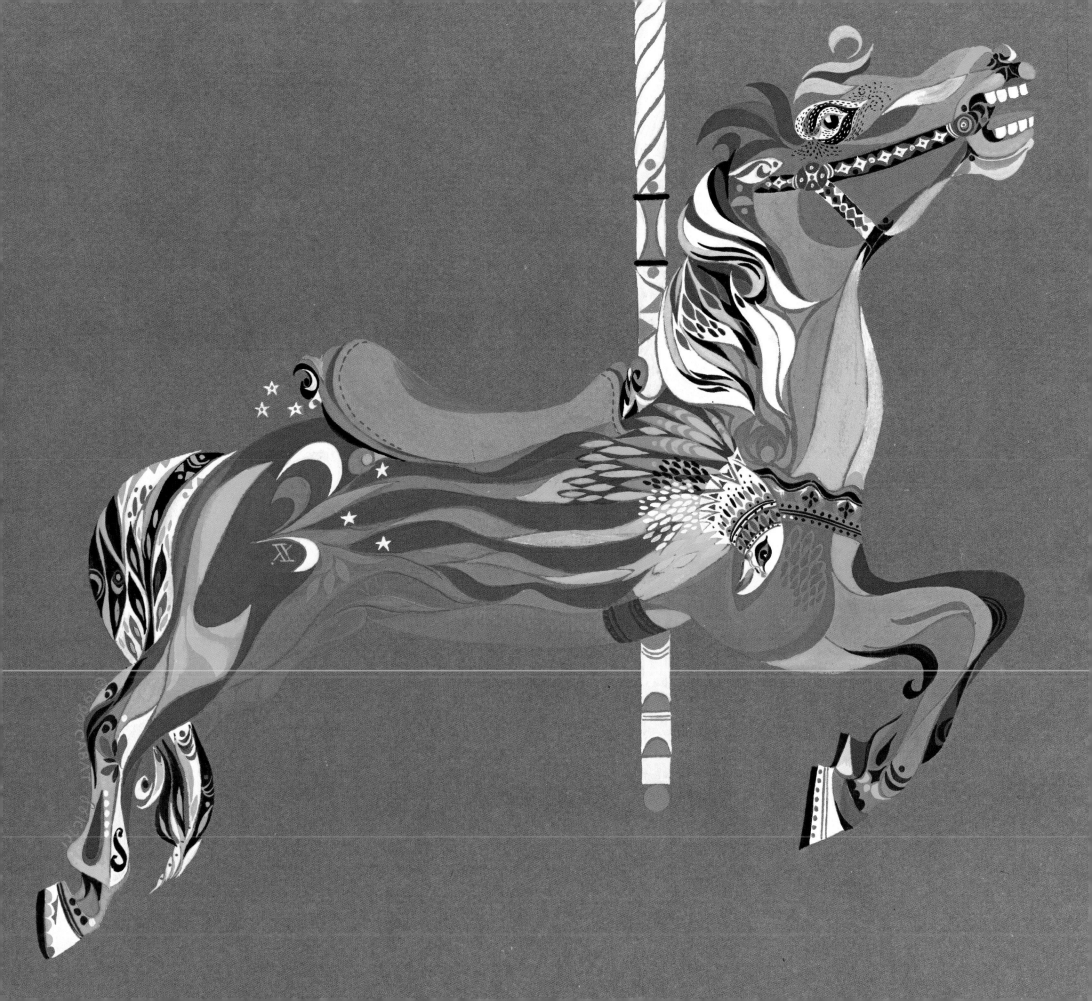

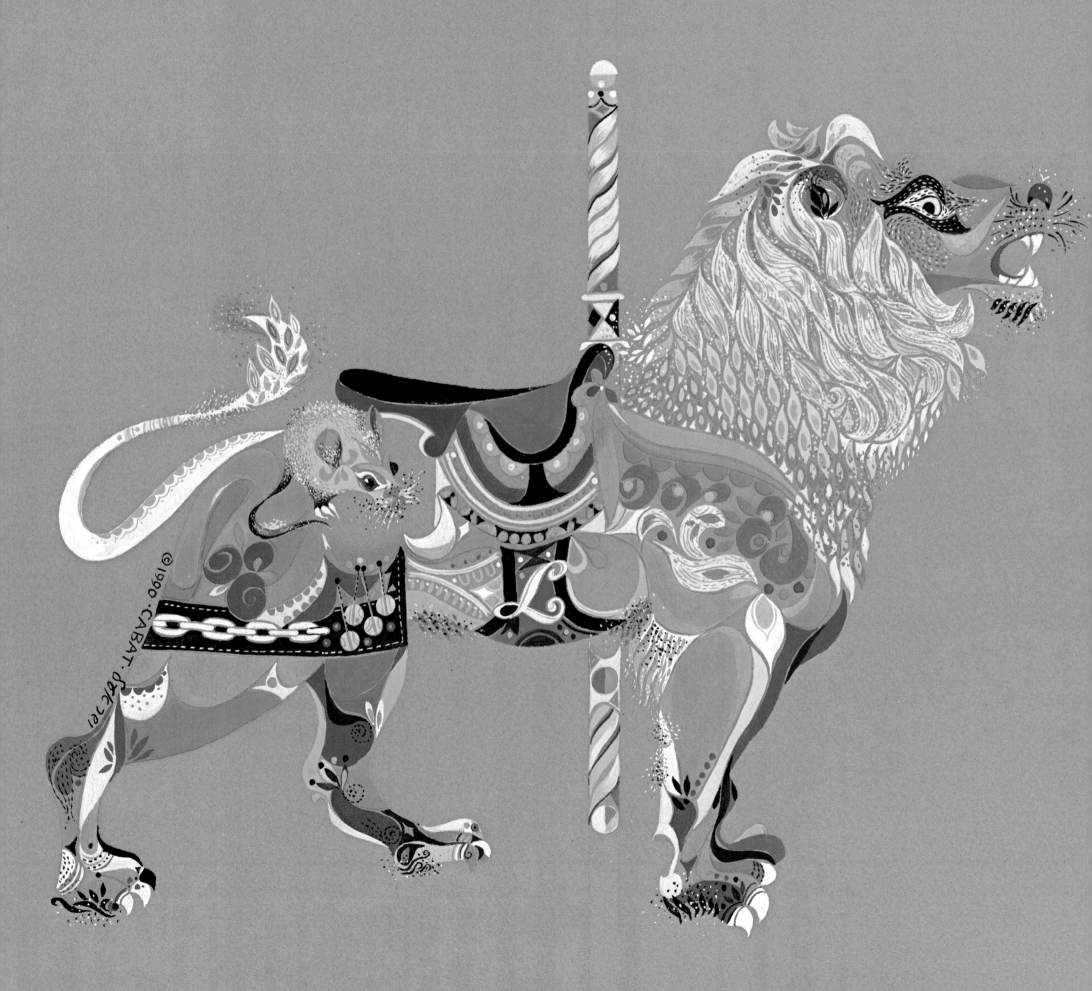

A lion caught a little mouse
 Beneath his heavy paws,
And raised him squirming by the tail
 Up to his gaping jaws.

"Stop, kind Sir!" the mouse implored,
 "Release me and I vow
That if you're ever in a fix,
 I'll help you out somehow."

"Oh, ho, now that is quite a joke,"
 The lion roared with glee,
"For what good is a puny mouse
 To one as great as me?"

"Still, I will let you go
 Because you've made me laugh today."
And so the lion freed the mouse
 And sent him on his way.

Now one day not long after that
 The mouse heard fearsome cries,
He scurried towards the bellowing
 And squeaked in great surprise.

For there beneath a hunter's net
 The lion roared with rage,
No matter how he thrashed and swiped,
 He could not rend his cage.

"Hold still," the little mouse piped up,
 "Such nets are to my taste,"
And so he set to gnawing through
 The ropes with lightning haste.

The lion soon was free and humbly said,
 "I never knew
A tiny creature like yourself
 Could be a giant too."

There's nothing quite as sporting
 As a good old British mount,
Indeed, as far as horses go,
 We're truly paramount.

And though it's said that England ruled
 By putting ships to sea,
I say she rose to glory
 On handsome steeds like me.

Of course, I do admit
 It was the British fleet
That dealt those mighty Spaniards
 And their ships a sound defeat.

But think, if I'd not borne Sir Francis
 To his ship that day,
The fleet would ne'er have hoisted sail
 And gotten underway.

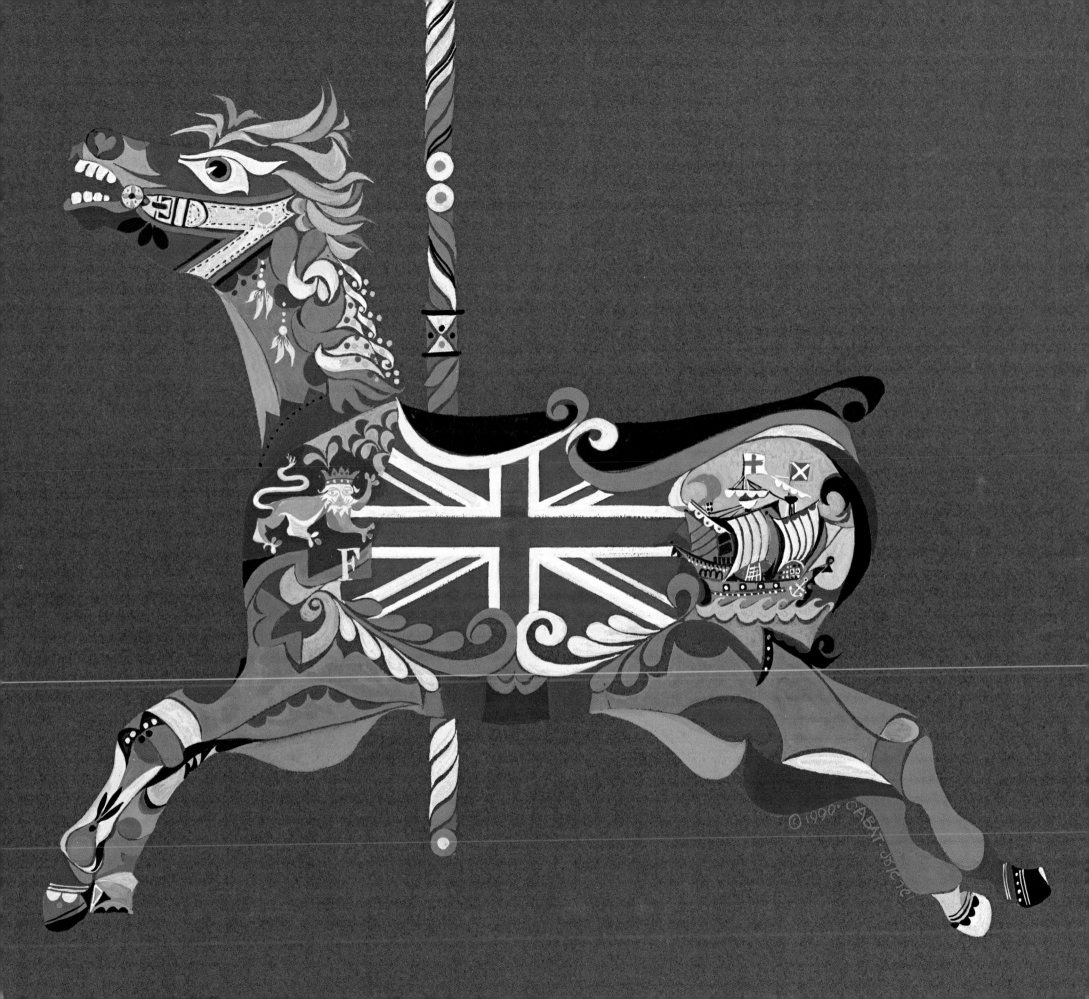

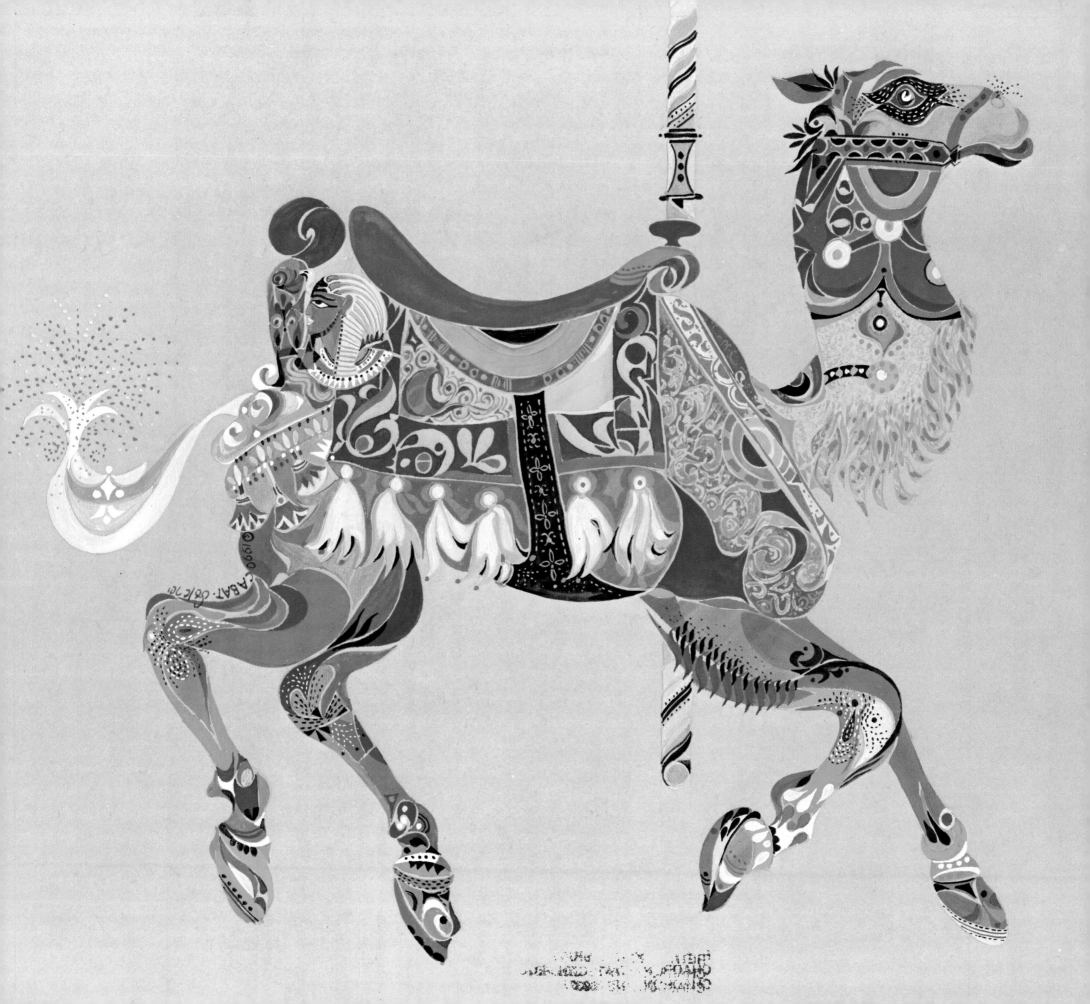

wish! Swirl!
The shifting sands
 Of Egypt beckon me
To cross the desert like a ship
 Upon a golden sea.

Oh, woe!
I long to go
 Where pharaohs used to dwell
Instead of riding up and down
 Around this carousel.

Hiss! Hoot!
Why must you choose
 Me as your mount today?
I warn you, I'm a sour sort
 Who'll kick and spit and bray.

Grunt! Groan!
What misery
 A beast like me must bear,
I turn forever round and round
 And yet I go nowhere.

In youth I was ugly,
 Without any grace,
The ducklings despised me
 And laughed in my face.

The geese and the chickens
 Hurled insults at me,
The hounds bared their sharp teeth
 And snarled fearfully.

Discouraged and friendless,
 I slipped off one night,
Away from the barnyard
 By the moon's eerie light.

All through the winter
 I wandered along,
In search of that one place
 Where I might belong.

When spring came at last
 I discovered a lake,
And saw swans so lovely
 They made my heart ache.

The swans called to me,
 Though I couldn't think why
Birds of such beauty
 Would want me nearby.

I crept forward shyly
 And lowered my eyes,
Then looked in the water
 And gasped in surprise.

I too was a swan,
 And a beautiful one,
With dazzling white wings
 All aglow in the sun.

I didn't feel bitter
 For all that had passed,
I felt only joy
 To be home at long last.

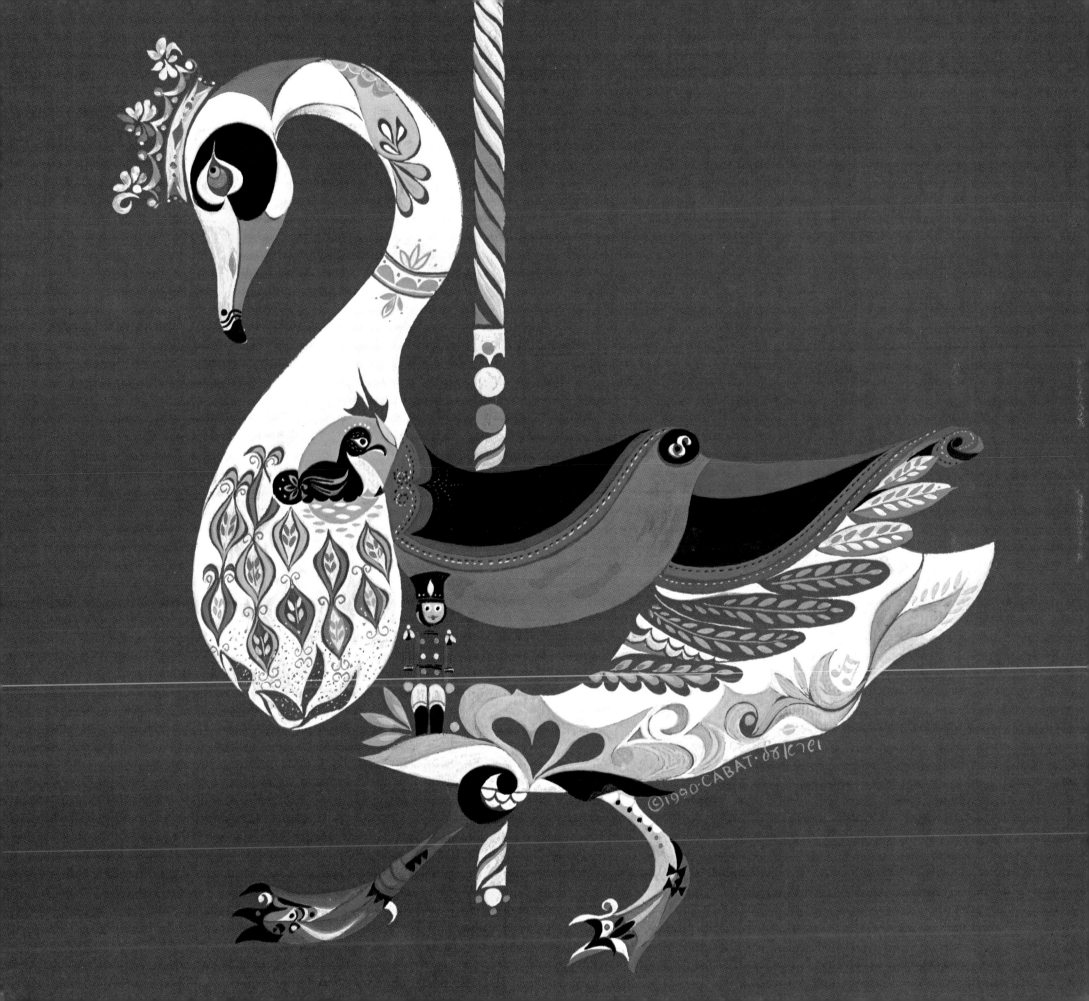

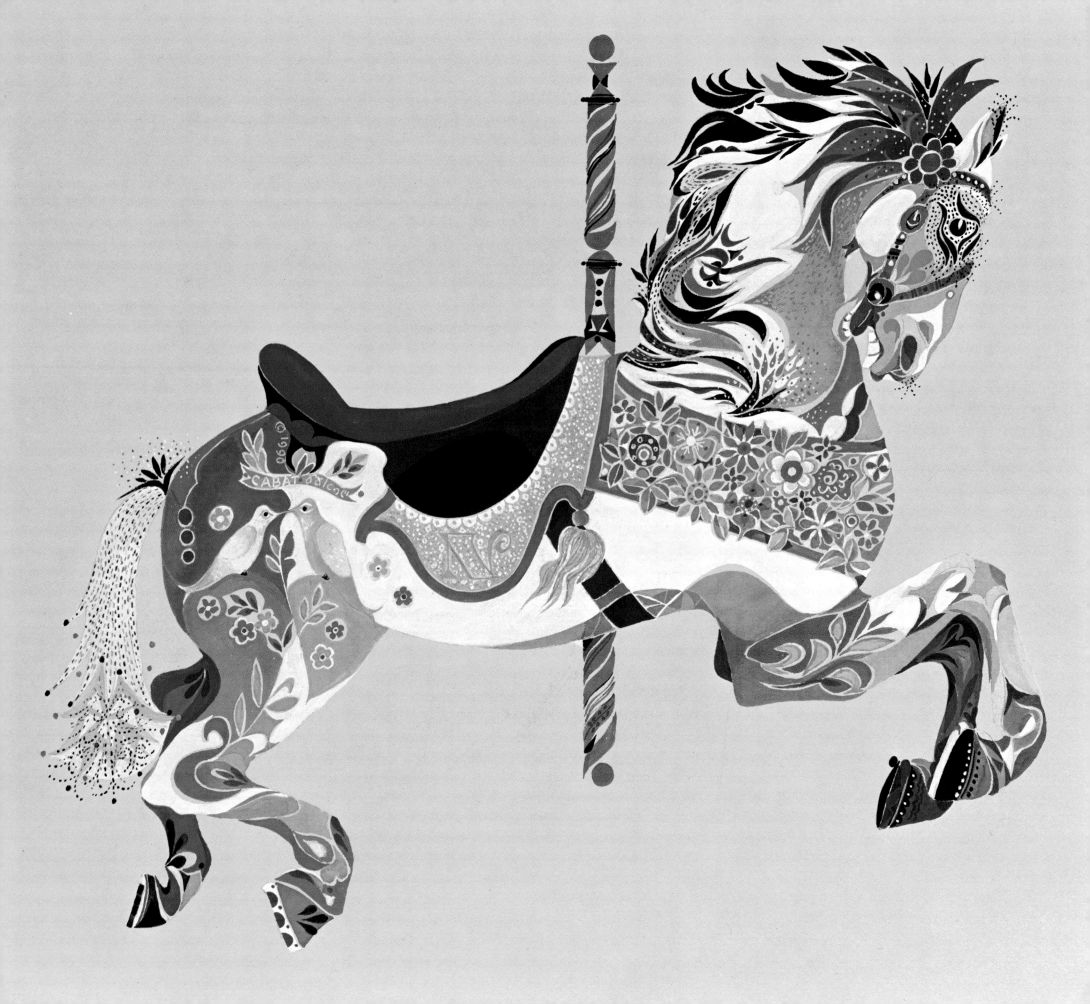

am Dreamer,
From the far-off land of fairy tales,
Come, and I will show you
Dozing daisy-covered dales.

There the gentle mourning doves
Will coo and nod their heads
While the fairies waken
From their fragrant flower beds.

Then those clever little folk
Shall let their nimble fingers fly
And weave us wreaths of blossoms
Sweeter than a baby's sigh.

Although I'm taller than a house
　And almost just as wide,
I'm really quite a friendly chap
　Beneath this tough old hide.

If you're in mind to move a mountain,
　I'm the one to ask,
With my broad back and shoulders
　I'll soon complete the task.

And if your car needs hosing down,
　I'll gladly help you out,
My long and curving trunk is better
　Than a water spout.

And should you feel the need
　To gawk and grin and giggle,
I'll ride a bike, stand on my head,
　And make my big ears wiggle.

So climb aboard my back
　And spend some time with me,
And see what jolly fun
　An elephant can be.

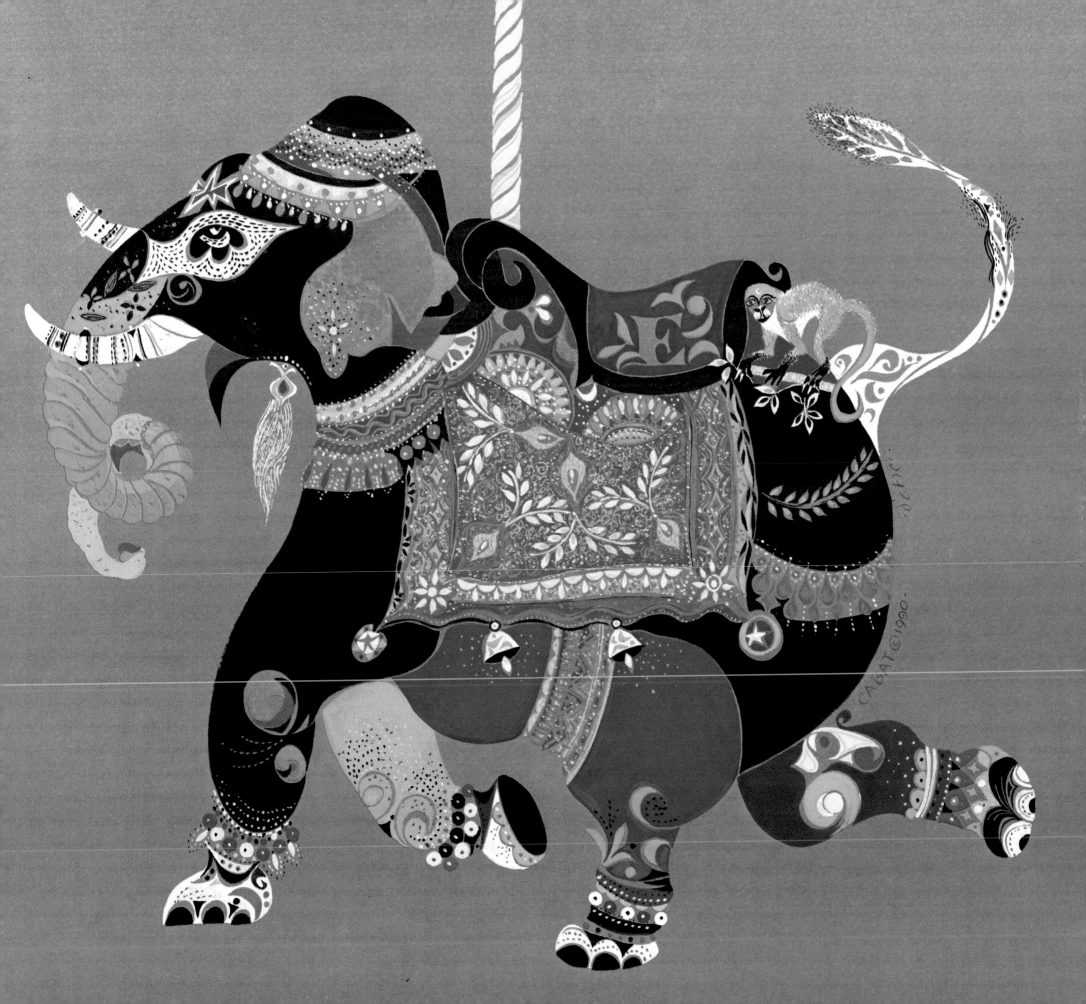

I am the stuff of fantasy,
The fabled Unicorn,
Men have long pursued me
For my legendary horn.

With voices soft and bridles bright
They coaxed and beckoned me,
But I refused to yield to them,
Preferring to be free.

But for you, dear child,
I'll bow my head and stay
To take you for a ride
Around the carousel this day.

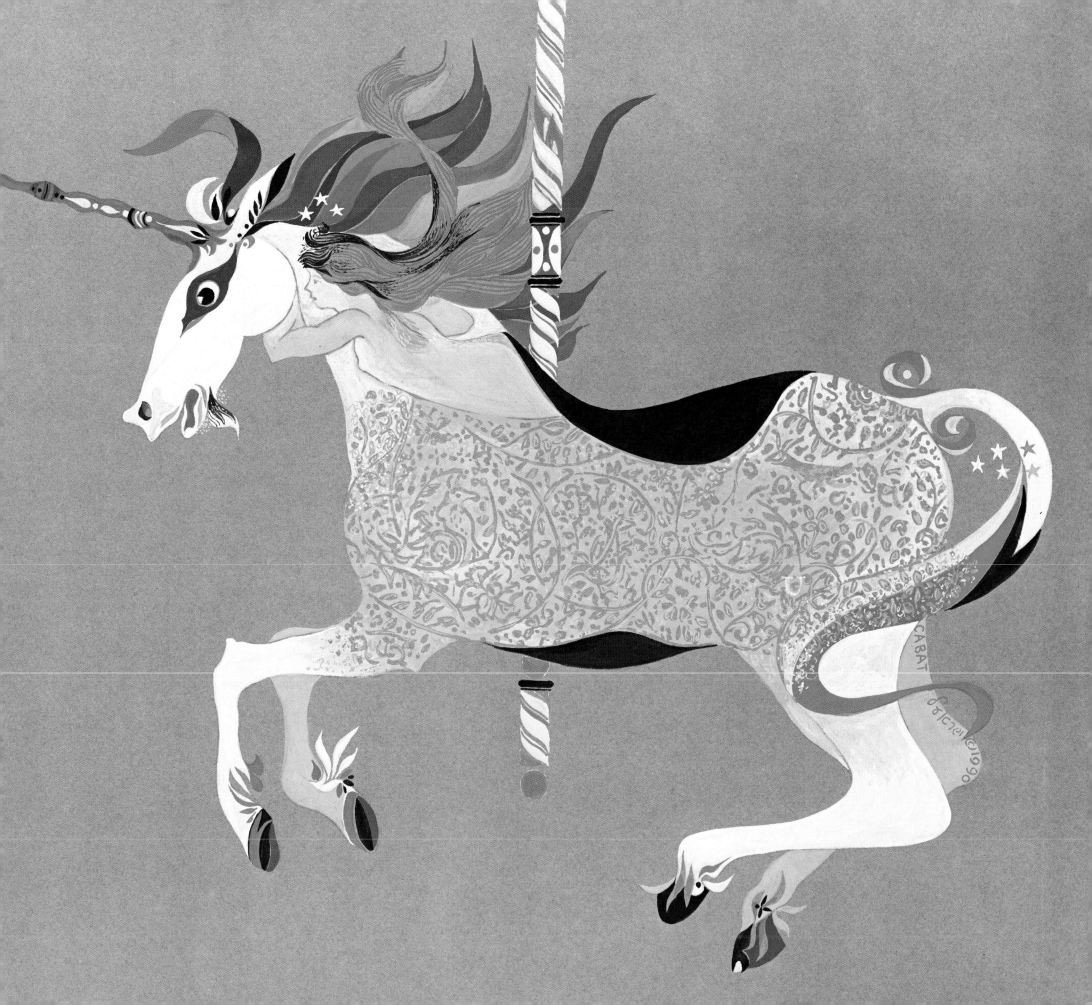

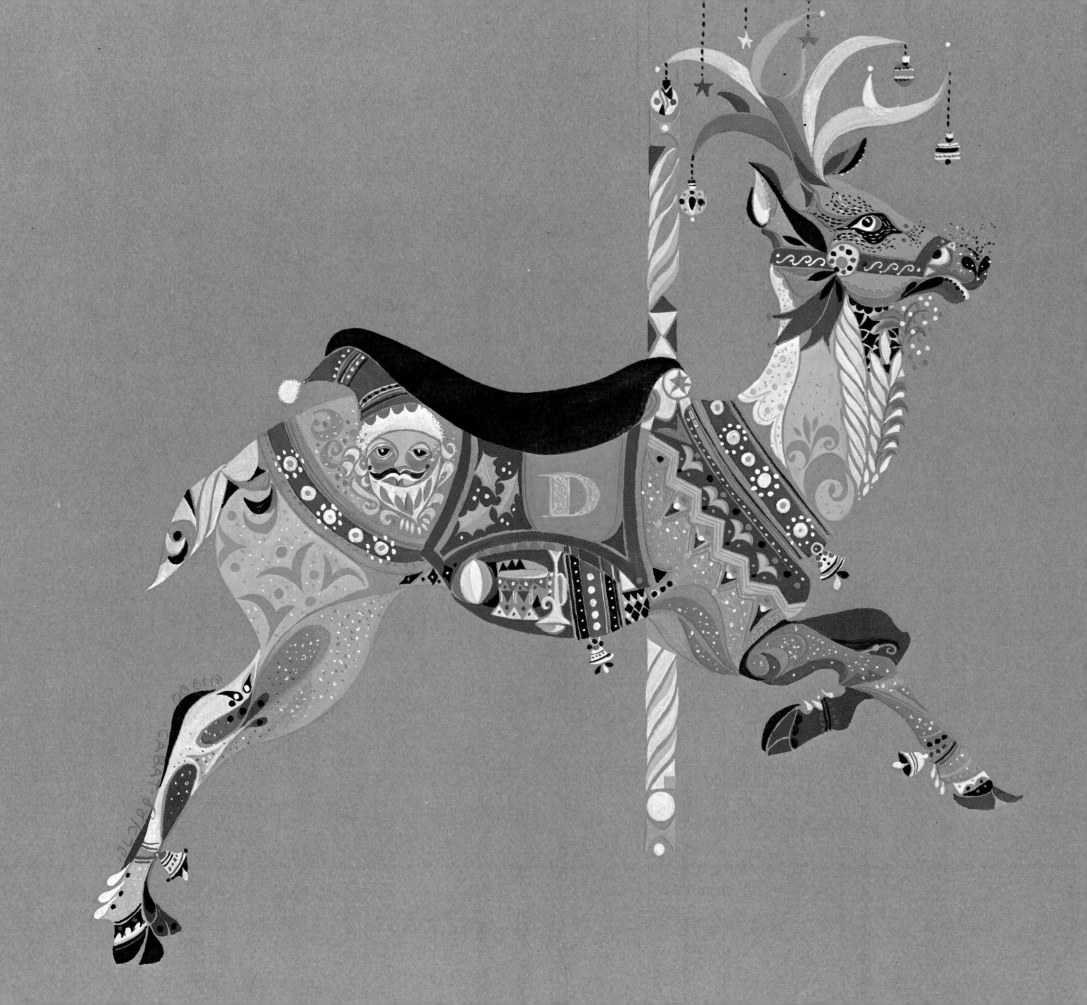

'm one of Santa's reindeer,
 We're a very merry crew,
We work the whole year through so that
 Your Christmas dreams come true.

While bright-eyed elves make dolls and bikes
 And tiny trains and cars,
We reindeer practice flying,
 Reaching always for the stars.

On Christmas Eve we're off with Santa,
 Racing through the sky,
The wind might howl and rage at us,
 But onward do we fly.

At every house we leave
 A pile of presents from our sleigh,
For children to discover
 When they wake on Christmas Day.

Come and join the good folk
 At the tournament today.
Sit beneath a canopy
 And watch the grand display.

Of the many steeds you'll see,
 I stand above the rest,
I've thunder in my dashing hooves
 And fire in my breast.

On my back there sits a knight,
 The bravest in the land,
His armor shined, his helmet plumed,
 A great lance in his hand.

We shall best them one and all
 And prove ourselves most bold,
Winning from the king a purse
 Of sparkling gems and gold.

Then as silken banners fly
 And golden trumpets blare,
We'll march smartly past the stands
 Our heads high in the air.

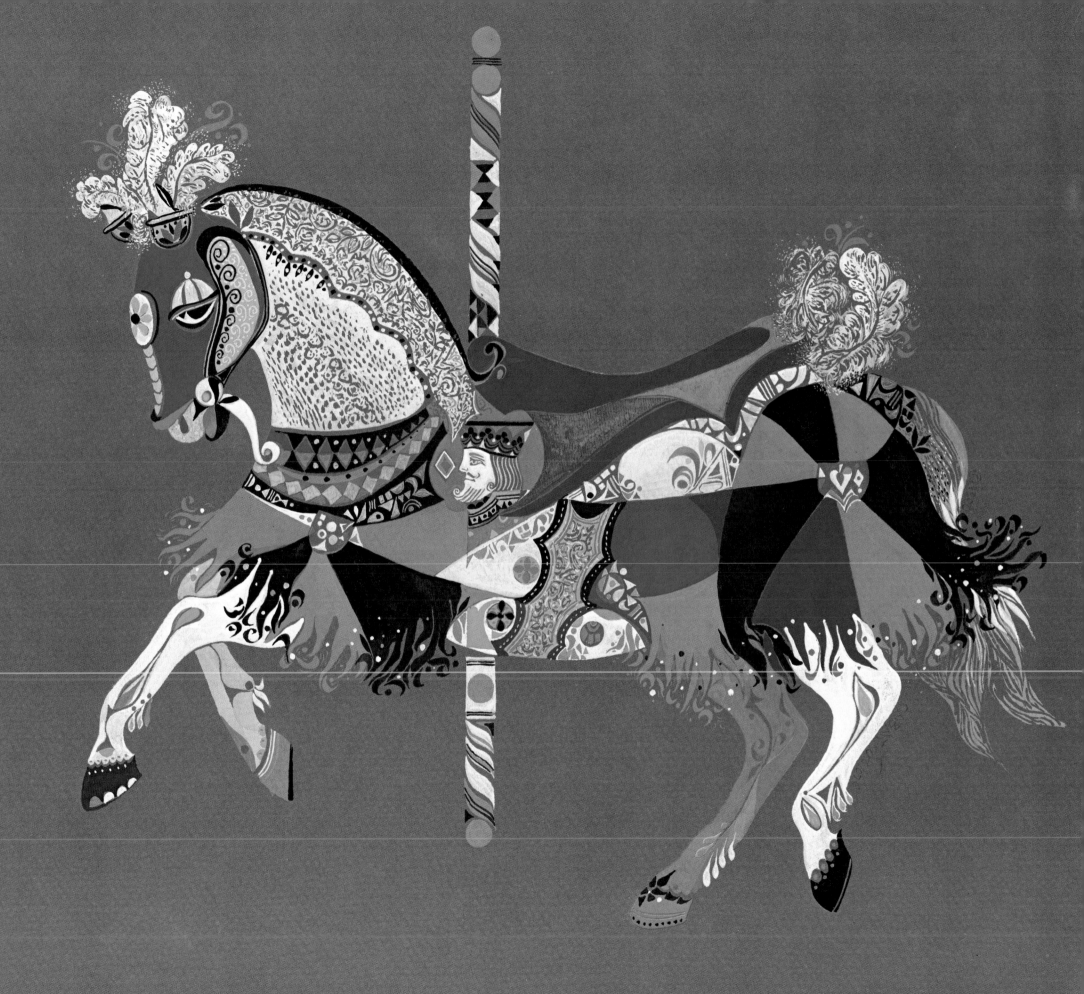

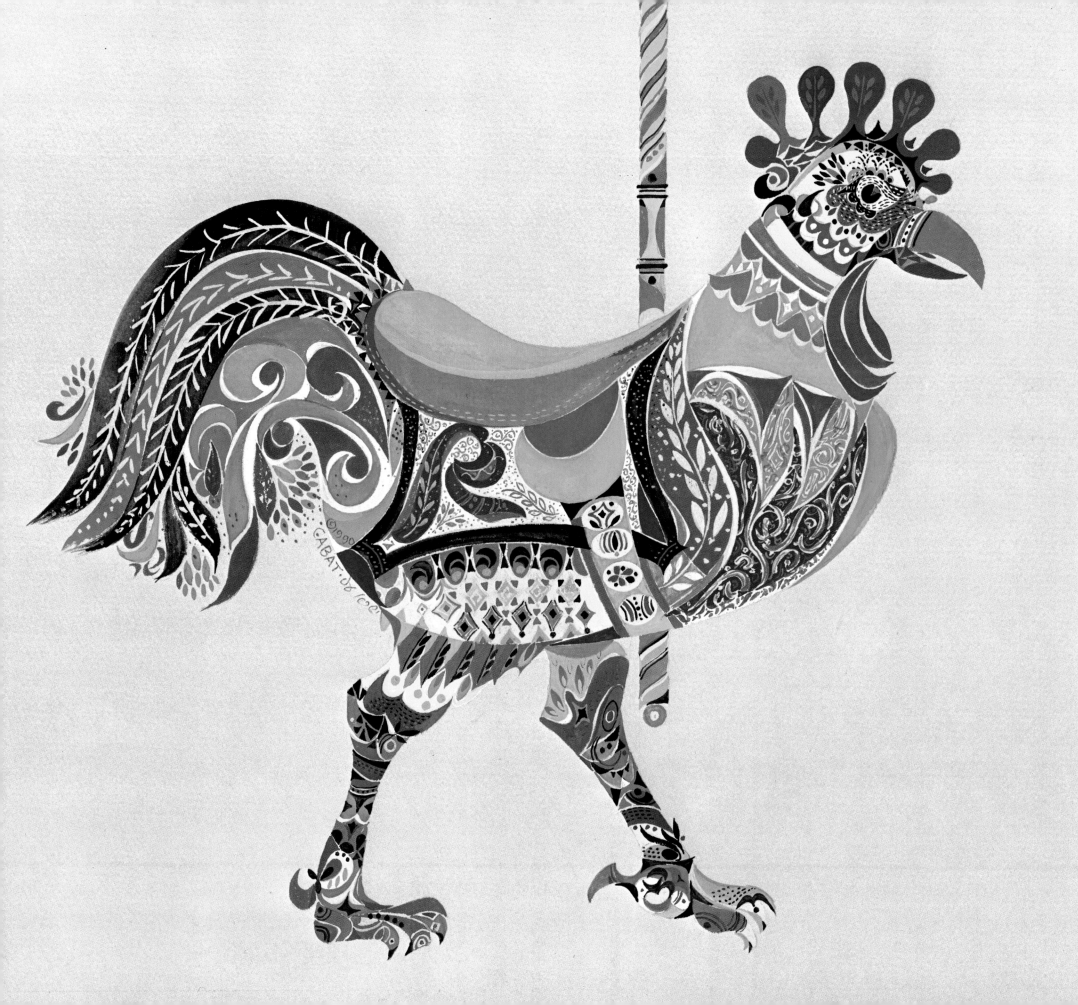

I'm a bantam rooster,
 What a mighty bird am I,
At my command the golden sun
 Lights up the morning sky.

It matters not how big
 A sleepyhead you might be,
I'll cock-a-doodle-doo you
 Out of bed in perfect key.

Angel is quite perfect,
 She combs her hair just so,
Her wings are always smooth and sleek,
 She's neat from head to toe.

But I'm a rough-and-tumble sort
 With a wild and tangled mane,
I'd rather frolic in the fields,
 I love the wind and rain.

Angel plays a trumpet,
 She practices each day,
She has a lesson book of scales
 That she must learn to play.

When my hooves drum out music
 Upon the firm hard ground,
They don't make notes or chords,
 But just a happy sound.

It's fine to be like Angel,
 A perfect little one,
But I am glad that I'm a horse,
 For I have all the fun.

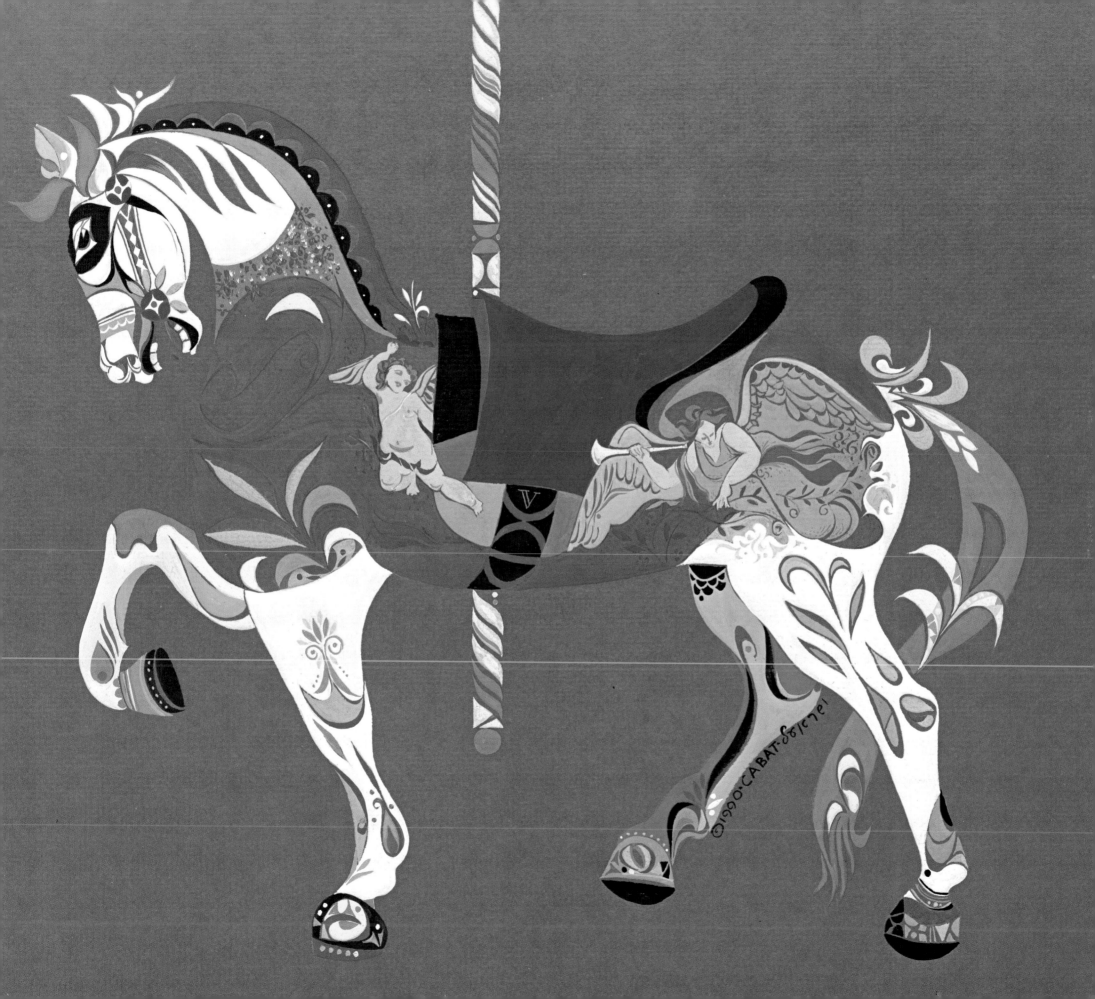

The Artist Talks About *Carousel*

Erni Cabat is sitting on a plain wooden stool, at a battered old table covered with a sheet of clean white paper. Books and papers crowd the edges of the table, piled in courses like bricks in a wall. The table is in the front room of his studio, which takes up an entire small house in Tucson, Arizona. The house is old and, like its occupant, filled with colors and pictures and books and ideas, heaped up like more bricks, awaiting the mason.

Erni is talking, and when he talks, his eyes shine and his hands move and his mustache goes up and down. The subject is art, the world, carousels, and Erni's vision of how it all goes together.

Why do a book of carousel animals? I can't really say *why* it happened, but I can say *how*. I was working on a book about dinosaurs, taking books out of the library and renewing the books and thinking about dinosaurs more and more, and all of a sudden along with the dinosaurs I was thinking about running horses, which translated into carousel animals.

I was thinking about how I felt about fairy tales and fantasy, the mystical and the mythical, gods and goddesses and heroes. It reminded me of when I was a kid on the Lower East Side in New York. My mother would give me a penny when the carousel man came around. He had a miniature carousel that was on a truck bed pulled by horses. You'd give him your penny and get on and he'd crank it up by hand—a minute or three minutes, depending on how tired he was. When I was twelve, we moved to the Bronx and that ended the carousel rides. But later in life, whenever I saw a carousel, I'd jump on it.

I don't claim to be a historian, but the anatomy of the animals in these pictures is correct in almost every case. I took out every book on carousels the library had and used them as my point of departure.

If I was designing carousels today, I would add things—whimsical things or humorous things or symbolic things that I think are important in today's culture. One of the things the old masters did was to incorporate popular symbols into their carousels, like angels and flags, and for the British, hunters and hounds. Later on, the Americans had Indian scouts and tomahawks and things like that.

I wanted this book to be educational and informative, as well as enjoyable. I've always wondered if it's possible to interest kids in letters by way of art, to create a love of color and design and art connected to a letter or a word so that they never forget it.

What I want to do most of all is create a desire to learn. Art can do it, and I can prove it. I've already done it. In the swan, for example, you've got the story of the Ugly Duckling, who turns into a beautiful swan. And then there's the *Nutcracker Suite*, which I felt goes with the swan, because of *Swan Lake*. So you can call this a Tchaikovsky swan if you want to, with the Ugly Duckling thrown in.

Now, in the lion, I remembered two stories, "Androcles and the Lion" and "The Mouse and the Lion." The lion roared and roared because he was caught in a trap, and the little mouse came up and said he would set the lion free. And then the mouse gnawed away on the rope. Well, here I used a chain symbolically because I felt it would be easier to grasp.

I put the eagle in because the eagle is an endangered species, and I like the eagle, and it's a symbol of our flag. Subtly, if you can see it, emanating from the eagle are the stripes of the flag. It's very subtle, but that was my intention.

Flags were very common symbols, particularly with the British carvers and some other nationalities. I wanted to do a flag animal, a flag horse, but I felt that some history ought to go into it. So the flag horse is a takeoff on an authentic sixteenth-century British warship flying a flag with the cross of St. George, which was an ancient symbol for England, and a flag with the cross of St. Andrew, which was a symbol for Scotland. In 1801, they were

both combined with the cross of St. Patrick, for Ireland, to make the British flag of today.

Then there's the camel. I felt people ought to know that the camel comes from Egypt, that Egypt's got desert sands and the camel can go forty days and forty nights with one drink of water. So that's why you have a pharaoh in there, to indicate the land of Egypt. And some of the lines are a little bit Egyptian, but of course camels belong to a lot of other peoples, too.

I've found that, unless it's a storybook, parents reading to toddlers are often at a loss to explain things to them. So what I'm hoping is that within the graphic elements and the symbols and the animals—the actual paintings—parents can find enough things to talk to their kids about. Another hope I have is that I'm creating a desire to know. So maybe a kid will say, "Mommy, what's that?" And then she can explain the thing.

Many people don't know that carousels had both horses and what were called "menagerie" animals. The menagerie animals were beautiful—wild animals, zoo animals, farm animals, mutt animals, run-of-the-mill animals. And unbelievable animals, and imaginary animals, dragons and fish that you never saw.

The elephant was one of my favorite menagerie animals to do, because sometimes you're running hot and everything just seems to jell. It just dovetails and it goes, goes, goes and it's a joy. The elephant was a joy—it just *went*.

All of the elephants I'd seen before were stationary, and with the exception of the horses galloping, most of the other animals were pretty staged, but my elephant, well, I just thought he should be trotting along. A favorite design symbol of Indian artists is the eye of the peacock, so I used that in the corners and created my own Indian rug.

They had deer in the menagerie, too, but nowhere did the carousel-builders translate the deer into a reindeer for Christmas. So I added bells and ornaments and Santa Claus and toys, things like that, as if Santa Claus was in a sled prancing through the snow. I wanted a joyous feeling.

Now, the unicorn was a very important fabled animal from way back. And he only responded to maidens of purity—they were the only ones who could calm him down. Otherwise he was a wild beast. And he had a nebulous feeling to me. He came and went and he disappeared, so I tried to create that in my design.

———

I don't do what they call comprehensive sketches—I never know how an animal is going to look when I start. I'm a great believer in accidental happenings and in taking advantage of them. I'll throw some idea on paper, just to see if it flies. And I may do a head roughly, or a tail, or I may just throw one color right across it, after I've done a rough sketch in pastel. Once I do an area like a head, it gives me an idea for what I want to do overall. And in good art, the minute you put down a spot of color or a shape, it affects the color or shape throughout the entire painting. You change one thing and you've got to adapt, relate, fix, add to, or subtract something else, someplace else.

Bear in mind that each one of these paintings is like an experiment to me. It's a challenge. I want to see how far I can go to break the rules of good art. My high-school teacher once told me to never put green next to red, so I want to see what happens when I do that. I want to know what happens if I explore a change in color, a change in shape, a change in design. This, and the learning process, is the whole basis for the enjoyment I get in doing these things.

Otherwise I would go crazy. Otherwise I would duplicate myself, and there's so much yet to explore without duplicating what I've already done. And that's my challenge, my overall great challenge, and that's what keeps me excited.

From an interview by Michael J. Rule
October, 1989